Twenty to Make
Art Dolls

Sarah Lawrence

Search Press

First published in Great Britain 2008

Search Press Limited
Wellwood, North Farm Road,
Tunbridge Wells, Kent TN2 3DR

Text copyright © Sarah Lawrence 2008

Photographs by Roddy Paine Photographic Studios

Photographs and design copyright
© Search Press Ltd 2008

ISBN: 978-1-84448-362-4

Printed in Malaysia

Dedication
For my daughter Fran, my mum Nancy,
my cousin Janet, and Tom and David,
of course.

Suppliers
Many of the materials and equipment mentioned
in this book can be obtained from the author's
own website:
www.craftynotions.com.
Alternatively, please visit the Search Press website
for details of suppliers: www.searchpress.com.

Although every attempt has been made to ensure
that all the materials and equipment used in this
book are currently available, the Publishers cannot
guarantee that this will always be the case. If
you have difficulty in obtaining any of the items
mentioned, then suitable alternatives should be
used instead.

Contents

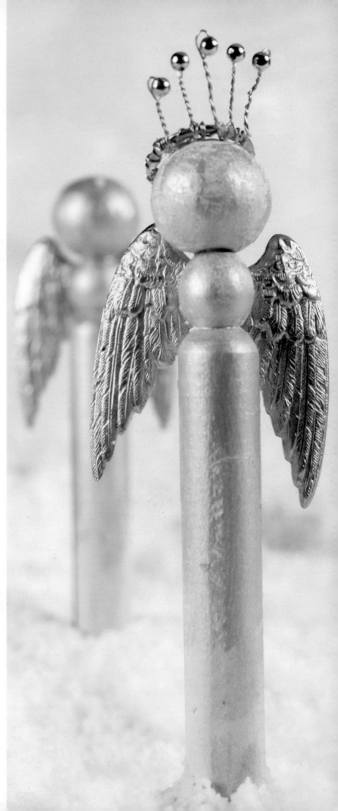

Introduction

Art dolls are, essentially, artistic interpretations of the human form, and can be made using any media including fabric, paper, card, wire, wood and metal. They are a lively and innovative method of self-expression and can be a celebration of self, an expression of sentiment, or simply quirky, fun creations. They are not designed as children's playthings, and indeed making them for this purpose is strongly discouraged because of the dangers posed to young children by the small beads and other tiny items that art dolls often contain.

To allow you to stamp your own personality on the dolls in this book, all the projects are open to interpretation, and the instructions for decorating the dolls have been kept as general as possible. Very few items will need to be acquired to make these art dolls, as you will probably all have a greater or lesser stash of creative commodities just waiting to be played with. Those items that do need to be purchased are widely available through reputable retail stores and, of course, over the internet (see page 2 for a further note on suppliers). For most of these projects you will need a basic tool kit consisting of: scissors, sewing needles, pliers and wire cutters, paintbrushes of various sizes and a selection of paints. Two of the projects require a sewing machine and some experience of free-machine embroidery, but both can be adapted to suit your own particular skills.

I hope that you have as much fun making the various art dolls in this book as I have. Apply your imagination, and use them as inspiration for your own creations.

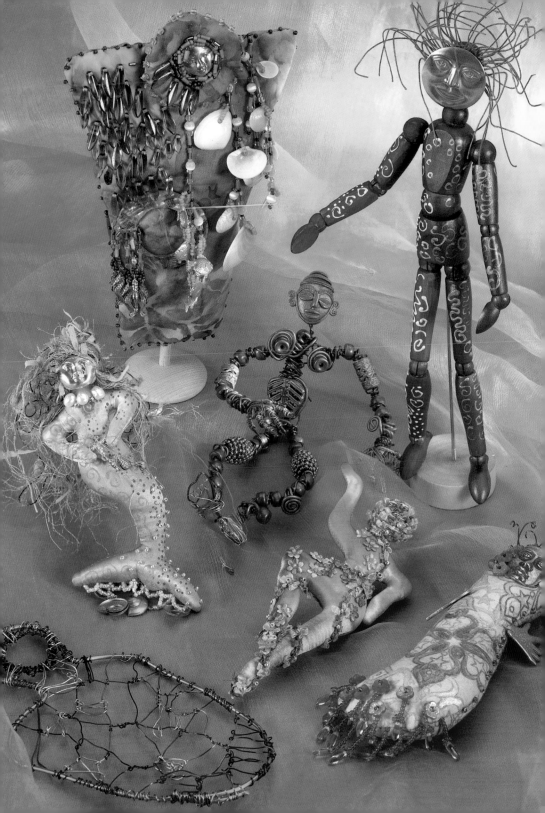

Tattooed Woman

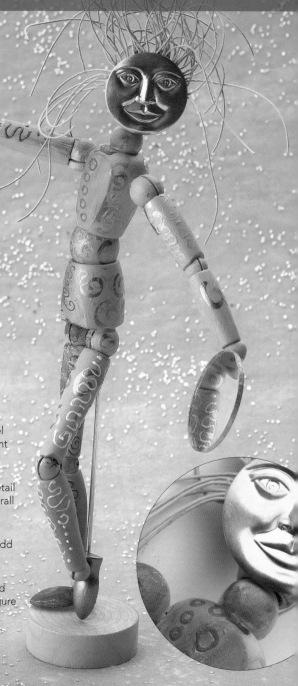

Materials:

One lay model (male or female)

Acrylic paints in various shades of blue and green

Gold acrylic paint

Large gold face charm

Gold butterfly charm and small mirror

Linen threads for hair

PVA or silicone glue

Tools:

Paintbrush

Mixing palette

Instructions:

1 Roughly paint the surface of the lay model using a mixture of colours. When dry, re-paint this layer.

2 Continue enhancing the painted surface, using delicate brush strokes to add more detail and give the whole surface an attractive overall pattern. Allow the paint to dry.

3 Attach the hair, face charm, mirror charm and any other embellishments you wish to add using glue.

4 Should you wish, the support for the lay model can be removed so that your tattooed figure can sit, for example on a shelf. The figure can be manipulated into any pose you wish!

Doll of Dreams
Altering the colours changes the mood of this doll dramatically!

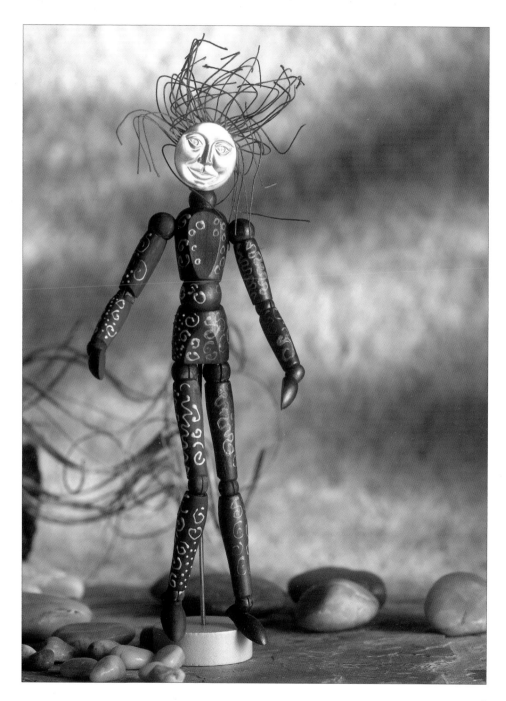

Flower Dancer

Materials:

Ready-made dancer doll blank

Silk paints or creative colour sprays in various colours

Silver face or mask charm, e.g. Artgirlz

Floral ribbon or braid

Sewing thread

Small fabric flowers in various colours

Pink and silver metallic seed beads

Tools:

Paintbrush and mixing palette

Sewing needle

Scissors

Instructions:

1 Spray or paint the doll blank with various coloured silk paints. Allow to dry.

2 Stitch the face charm in position.

3 Wrap the floral ribbon or braid several times around the face and around the body. Stitch it in position.

4 Add fabric flowers where you feel they would be most appropriate. Sew a single seed bead in the centre of each one.

5 Attach seed beads, regularly spaced, along the length of the ribbon or braid.

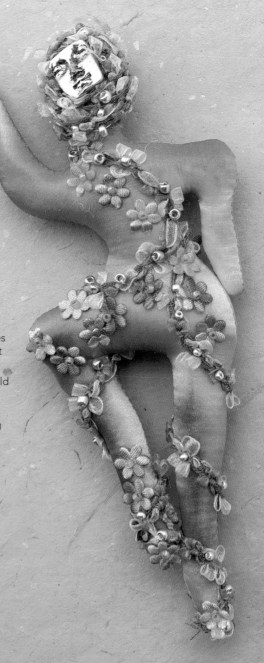

Dancing Diva

Use greens and blues combined with subtle embellishments for a more sophisticated dancer.

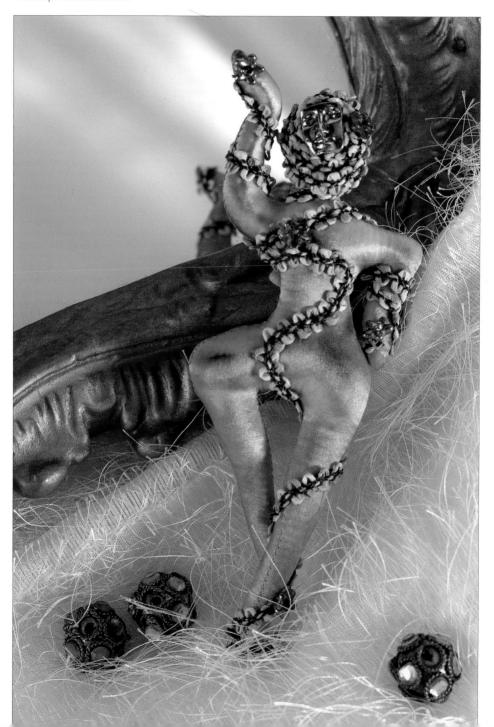

Sea Maiden

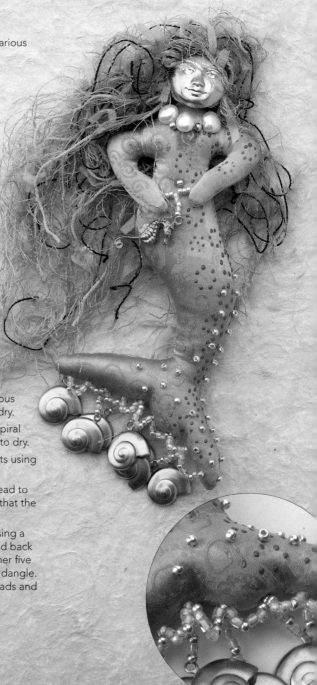

Materials:

Ready-made mermaid doll blank

Silk paints or creative colour sprays in various shades of blue and green

Blue and gold acrylic paint

Brass face or mask charm

Various decorative threads for hair

Sewing thread

Silver-, gold- and yellow-coloured seed beads

Three freshwater pearl beads

Gold seahorse charm

Six gold seashell charms

Tools:

Paintbrush and mixing palette

Sewing needle

Scissors

Instructions:

1 Paint or spray the doll blank with various shades of blue and green and allow to dry.

2 Decorate one side of the body with spiral patterns using gold acrylic paint. Allow to dry.

3 Paint the other side with circles of dots using blue acrylic paint.

4 Stitch decorative threads on to the head to form the hair. Attach the face charm so that the hair sits behind it.

5 Link the ends of the arms together using a string of five seed beads. Pass the thread back through two beads and thread on another five beads and a seahorse charm to make a dangle. Take the thread back up through the beads and fasten it off at the arm.

6 Edge the mermaid's tail with loops of between five and seven seed beads.

7 Add a dangle between each loop – attach the thread between the first two loops, thread on between five and seven beads followed by a seashell charm, then take the thread back through the beads, through the fabric and bring it out between the next two loops along.

8 Make a necklace using the pearl beads and gold seed beads and attach it around the mermaid's neck.

9 Complete the mermaid by stitching individual beads to the right-hand side of the mermaid's body and tail.

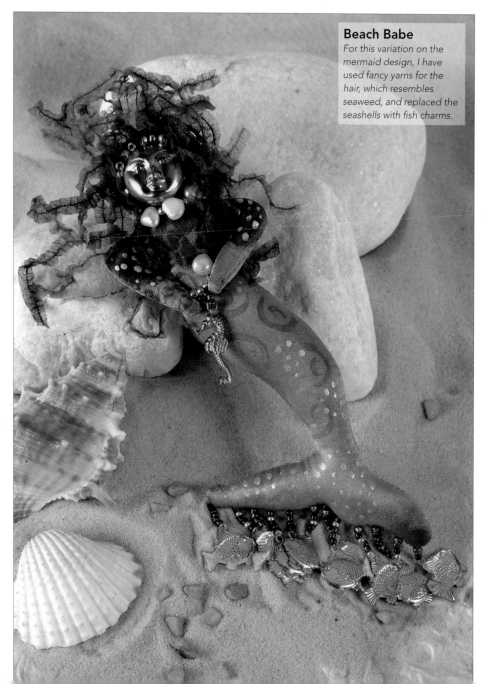

Beach Babe

For this variation on the mermaid design, I have used fancy yarns for the hair, which resembles seaweed, and replaced the seashells with fish charms.

African Doll

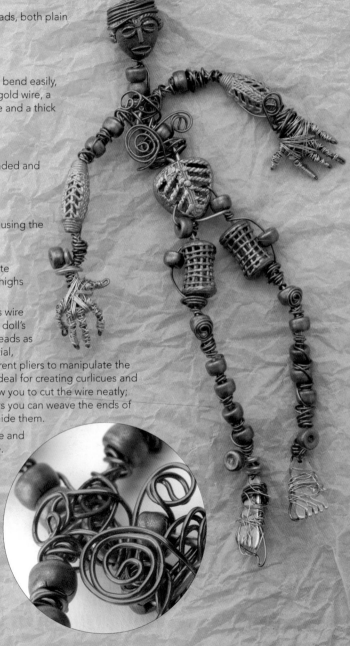

Materials:

A selection of ethnic metal beads, both plain and decorative

Metal face charm

Two silver foot charms

Various soft wires that you can bend easily, including a fine (34 gauge) gold wire, a medium-weight copper wire and a thick (18 gauge) lime green wire

Tools:

Pliers – needlepoint, round-ended and side-cutting

Instructions:

1 Create a rough body shape using the thick lime green wire.

2 Thread on the larger metal decorative beads in appropriate positions for the lower arms, thighs and abdomen.

3 Wrap the medium-thickness wire around various sections of the doll's limbs, adding smaller metal beads as well to create a more substantial, decorated structure. Use different pliers to manipulate the wire: round-ended pliers are ideal for creating curlicues and spirals; side-cutting pliers allow you to cut the wire neatly; and with the needlepoint pliers you can weave the ends of the wire into the wirework to hide them.

4 Create the basic head shape and the hands using the same wire.

5 Carefully wrap the fingers, palm and back of each hand with the fine gold wire.

6 Attach the foot charms to each leg, and wrap them randomly using the gold wire.

7 Finally, add the face charm, binding it to the head using the medium-weight copper wire.

Queen of Africa

Have fun experimenting with different coloured wires and types of beads – the possibilities are endless!

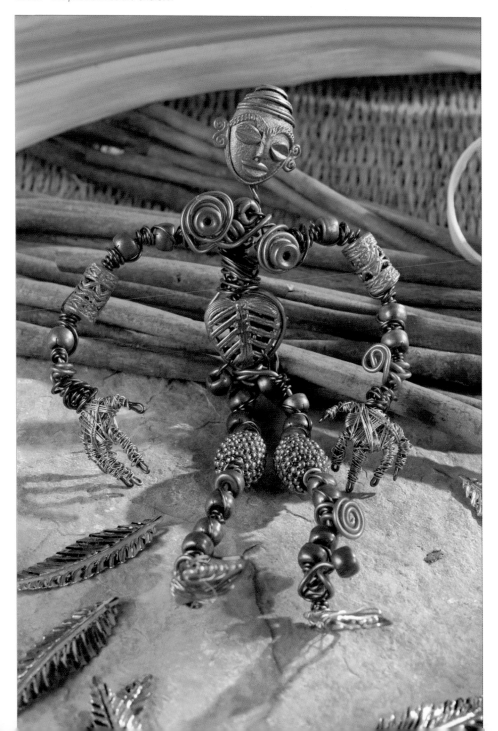

Jumping Jack

Materials:

A selection of large wooden beads

One large, round wooden bead for the head

Silver seed beads (with large holes)

Large fabric flowers in different colours

Two foot charms and two hand charms,
 e.g. 'Flat Foot' and 'Cartoon Hand' by Artgirlz

Strong sewing thread

Tools:

Large tapestry needle

Scissors

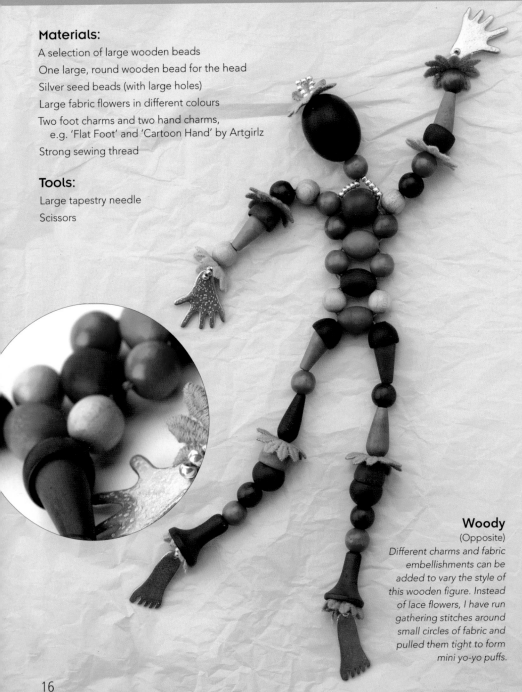

Woody

(Opposite)
Different charms and fabric embellishments can be added to vary the style of this wooden figure. Instead of lace flowers, I have run gathering stitches around small circles of fabric and pulled them tight to form mini yo-yo puffs.

Instructions:

1 Thread a needle with a long length of thread. Pass the thread through the bead that will form the head. Add a small round bead for the neck, and five seed beads for one shoulder.

2 Pass the thread through a large round bead to form the top part of the body. Thread on a series of beads to form one arm, using the picture for guidance. At the end of the arm add a fabric flower, three seed beads, a hand charm and three more seed beads. Pass the thread back up through all the beads forming the arm.

3 Start to form the body by adding a small bead followed by a large oval bead. Repeat this twice more; the large beads will form the centre of the body and the smaller beads will form one side.

4 Create a leg in the same way as the arm, this time adding a foot charm at the end. Pass the thread back up through the leg beads and through the large oval bead at the base of the body.

5 Repeat step 4 for the second leg. Add another small bead, pass the thread through the next large oval bead and repeat. Add another small bead and form the second arm (see step 2).

6 Pass the thread through the large round bead at the top of the body, add five seed beads for the shoulder, then pass the needle and thread up though the neck and head. Add a fabric flower and a loop of seed beads on the top of the head so that the doll can be dangled.

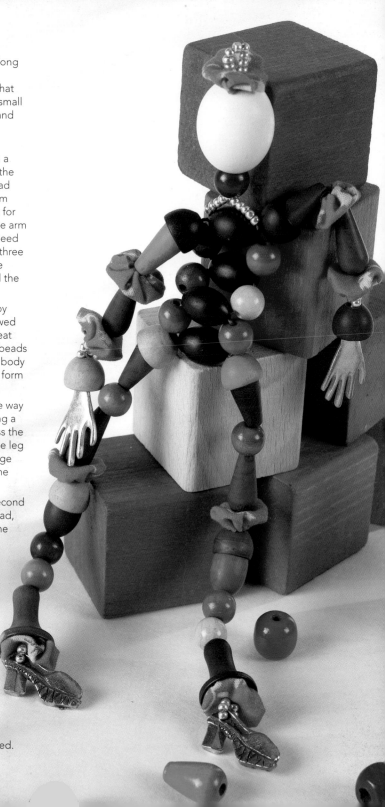

Time Lines

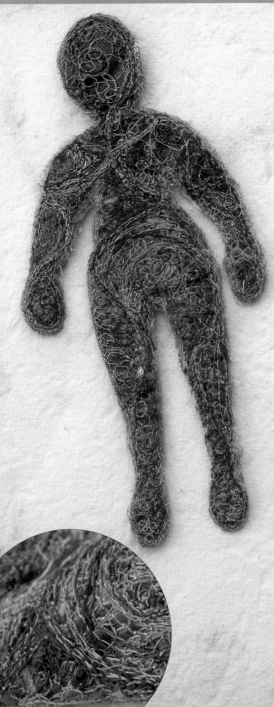

Materials:

Template 1

Two pieces of fine, sheer fabric, each 25.5cm
(10in) square

Different coloured and variegated
machine threads

Lightweight water-soluble film, e.g. Romeo

Craft felt

Tools:

Sewing machine, set to free-machine mode

Scissors

Pins

Ballpoint pen

Instructions:

1 Sandwich one piece of the sheer fabric
between two layers of water-soluble film.

2 Pin on template 1 and draw round it using a
ballpoint pen.

3 Repeat steps 1 and 2 with the second piece
of fabric.

4 With your machine set to free-machine
mode, sew around each outline three or four
times to form a stable edge for hand sewing
later on. Then, with small, circular movements,
fill in the two body shapes. You will find that
the more dense the stitching, the firmer your
resulting fabric will be. To add more colour
variation, use a variegated thread in
the bobbin.

5 When you have filled the shapes sufficiently,
cut around the outlines and immerse the two
body shapes in a bowl of water. Allow the
water-soluble film to dissolve. Take the stitched
bodies out of the water and allow them to dry.

6 Use the template to cut a body shape out
of the craft felt. Trim it so that it is a millimetre
or so smaller all round. Place this between the
two stitched body parts and hand sew around
the edge. If you wish to make the body slightly
more padded, add another layer of felt.

Funky Figures

An almost infinite range of patterns and designs can be created using this technique.

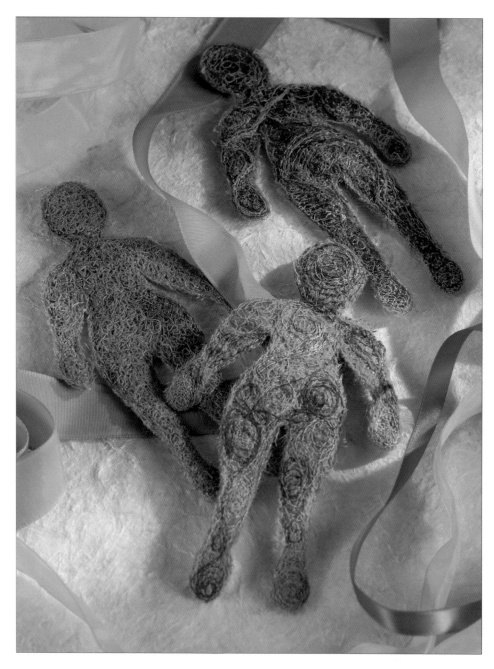

Flora

Materials:

Template 2

Craft stamp, e.g. Gemstone design by Stamptivity

Red solvent inkpad, e.g. StazOn

Gold and silver acrylic paints

Silver face charm, e.g. Artgirlz

Two hand charms,
 e.g. 'Cartoon Hand' by Artgirlz

Small blue flower beads

Blue and gold seed beads

Clear blue pendant beads

Medium-gauge pink wire

Plain pink cotton fabric

Toy stuffing

Sewing thread

Tools:

Paintbrush

Round-nosed pliers

Wire cutters

Scissors

Pins

Sewing needle

Instructions:

1 Stamp the design randomly on to the fabric using the red inkpad. Allow ten minutes for it to dry properly and then paint in selected areas with the acrylic paints. Allow to dry.

2 Fold the fabric in half, with the decorated sides together, and cut out two shapes using template 2. Either hand or machine stitch the two cut-out pieces together, leaving a 2cm (¾in) gap down one side. Turn right-side out.

3 Insert toy stuffing to create a rounded body shape and close the gap using hand stitching.

4 Cut five 4cm (1½in) lengths of wire and fold them in half. Secure the base of each folded wire approximately 1cm (½in) below the top of the shape, on the front. Stitch on the face charm so that it overlaps the base of the wires.

5 Sew on a selection of flower beads, with a gold-coloured seed bead in the centre of each one, around the face and along the base of the doll.

6 Stitch the hand charms in position.

7 Make beaded drop-tassels using blue seed beads and a pendant bead, and stitch one beneath each flower bead along the base.

8 Finally, curl the wire hair using round-nosed pliers and sew evenly spaced seed beads along the seam.

Star Struck

Create a different theme by replacing the flowers with star embellishments and printing on a star design.

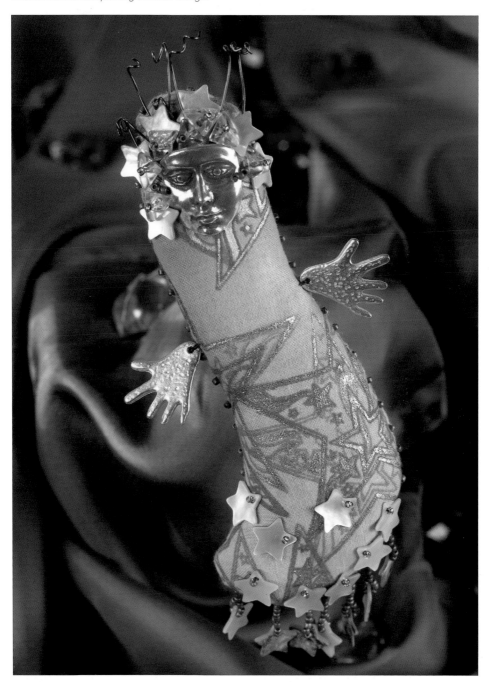

Vintage Angel

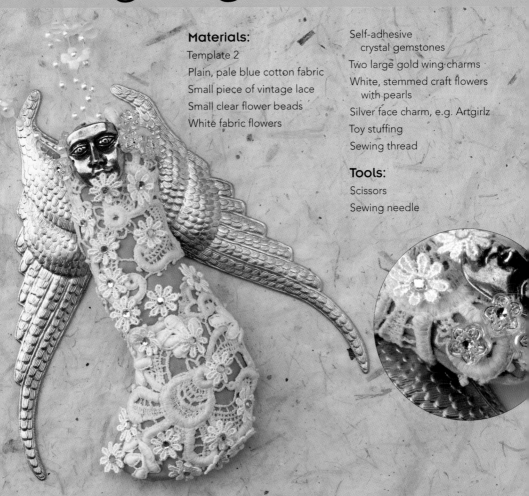

Materials:

Template 2

Plain, pale blue cotton fabric

Small piece of vintage lace

Small clear flower beads

White fabric flowers

Self-adhesive
 crystal gemstones

Two large gold wing charms

White, stemmed craft flowers
 with pearls

Silver face charm, e.g. Artgirlz

Toy stuffing

Sewing thread

Tools:

Scissors

Sewing needle

Instructions:

1 Fold the fabric in half with the right sides together and cut out two body shapes using template 2.

2 Either hand or machine stitch the two cut-out pieces together, leaving a 2cm (¾in) gap down one side.

3 Turn right-side out and fill the body with toy stuffing until it is nicely rounded, and hand sew the gap together.

4 Wrap the vintage lace around the front of the doll and stitch it in place.

5 Stitch on the white fabric flowers and attach a gemstone to the centre of each one. Sew the stemmed craft flowers just below the top of the head on the front of the doll, and stitch on the face charm so that it overlaps the base of the flowers. Attach the flower beads around the face.

6 Complete the doll by sewing the large gold wings on the back.

Heavenly Grace

*Vary the colour of the background fabric and the embellishments for
a very different effect.*

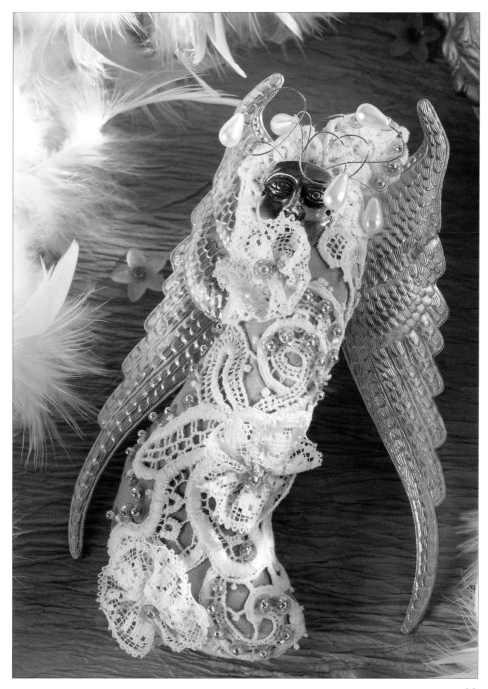

Statuesque

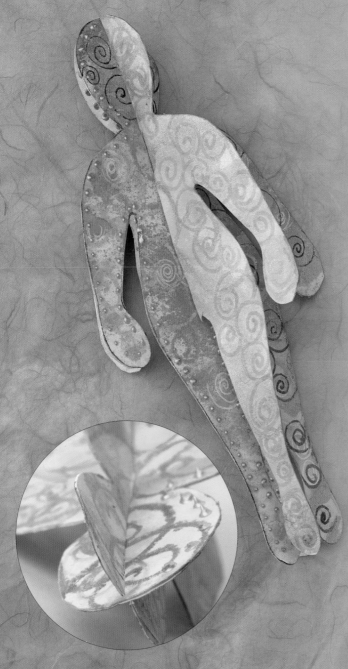

Materials:

Template 1

Light- to medium-weight card

Various metallic wax crayons

Watercolour paint in shades
of yellow, green and
light brown

Lime green acrylic paint

Tools:

Scissors

Paintbrush and mixing palette

Instructions:

1 Cut out two body shapes
using template 1.

2 Draw swirling patterns on
both surfaces of each one
using wax crayon.

3 Paint over one surface of
each shape with various pale
tones of watercolour paint
(the wax crayon resists the
water-based paint). Allow to
dry, then repeat on the other
surface of each shape.

4 Repeat steps 2 and 3, using
slightly deeper tones of
watercolour paint.

5 Add dots of acrylic paint
around the left-hand side
of each shape, on one
surface only.

6 Cut a slot from the top of
the head to the middle of the
chest of one body shape, and
from the base of the body to
the same point on the chest
of the other shape. Fit the two
pieces together.

Painted Lady

You can add whatever designs you choose to your paper doll, using a variety of paint media.

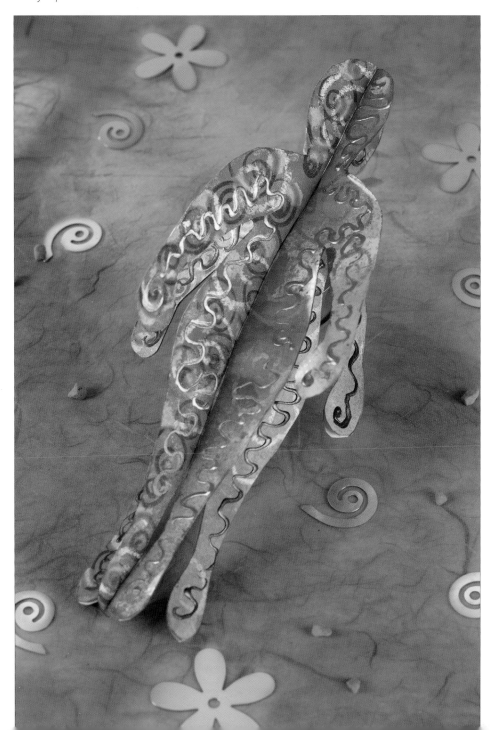

Peggy Sue

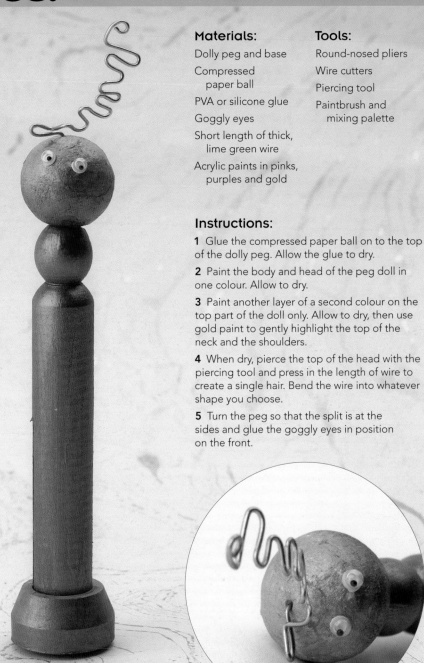

Materials:

Dolly peg and base

Compressed
 paper ball

PVA or silicone glue

Goggly eyes

Short length of thick,
 lime green wire

Acrylic paints in pinks,
 purples and gold

Tools:

Round-nosed pliers

Wire cutters

Piercing tool

Paintbrush and
 mixing palette

Instructions:

1 Glue the compressed paper ball on to the top of the dolly peg. Allow the glue to dry.

2 Paint the body and head of the peg doll in one colour. Allow to dry.

3 Paint another layer of a second colour on the top part of the doll only. Allow to dry, then use gold paint to gently highlight the top of the neck and the shoulders.

4 When dry, pierce the top of the head with the piercing tool and press in the length of wire to create a single hair. Bend the wire into whatever shape you choose.

5 Turn the peg so that the split is at the sides and glue the goggly eyes in position on the front.

Peg Family

By simply placing the eyes in different positions and bending the wire in various ways you can create a whole family of peg people, each with their own personality!

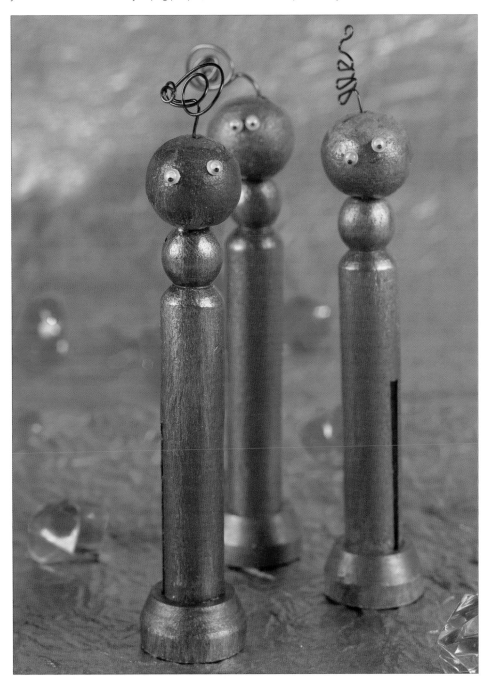

Angelica

Materials:

Dolly peg
Compressed paper ball
PVA or silicone glue
Gold curtain ring
Fine gold wire
Small round gold beads
Small piece of vintage lace for the dress
Small canvas-covered block
Acrylic paint in pale blue, dark pink and gold
Sewing thread

Tools:

Round-nosed pliers
Paintbrush and mixing palette
Sewing needle
Scissors

Instructions:

1 Glue the compressed paper ball to the top of the peg. Allow to dry.

2 Paint the peg doll, including the head, with the pale blue paint. Allow to dry. Paint parts of the head, neck and shoulders using the gold paint and leave to dry.

3 Paint the canvas-covered block using dark pink, allow it to dry, then paint on patches of gold paint. When dry, glue the base of the peg to the canvas-covered block.

4 To create the crown, wrap the gold wire around the curtain ring and every now and then bend the wire upwards, thread on a gold bead and fold the wire back down to form a stem with the bead at the top. Twist the two wires forming the stem together and continue round.

5 Sew up one side of the dress, and sew a line of gathering stitches around the top. Place the dress over the angel's head and gather it around her shoulders.

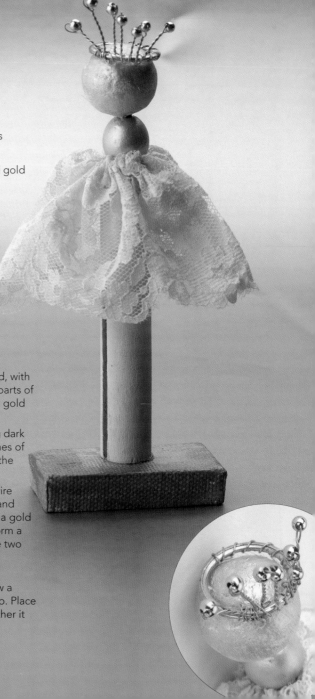

28

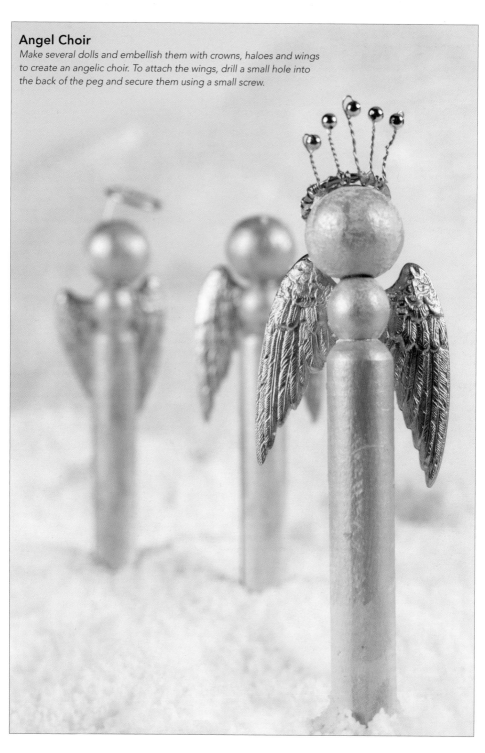

Angel Choir

Make several dolls and embellish them with crowns, haloes and wings to create an angelic choir. To attach the wings, drill a small hole into the back of the peg and secure them using a small screw.

Belinda Ballerina

Materials:

Dolly peg and base

Craft stamps for face and dress, e.g. 'Faces' and 'Queen's Rule' by Artgirlz

Two small hand charms, e.g. 'Little Hand' by Artgirlz

Short length of medium-weight turquoise wire

Four pearlescent blue seed beads and two larger white beads

Small piece of lightweight card

Black solvent inkpad, e.g. StazOn

Acrylic paints in turquoise, yellow and blue

Colouring pencils

Tools:

Round-nosed pliers

Paintbrush and mixing palette

Scissors

PVA or silicone glue

Instructions:

1 Stamp the dress and face design on to the lightweight card.

2 Colour them in using the coloured pencils and cut them out.

3 Paint the peg and stand using the turquoise acrylic paint and allow to dry. Paint on the stockings and shoes.

4 When dry, twist the wire around the neck of the peg doll to form the arms and thread on the beads. Attach the hand charms to the two ends of the wire.

5 Glue the face and dress in position on the peg.

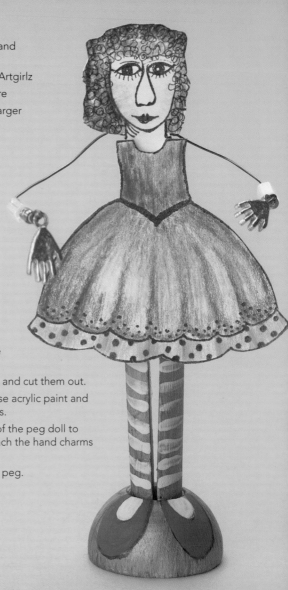

Dancing Doris

Ring the changes by using different stamps, colours and beads.

Summer Goddess

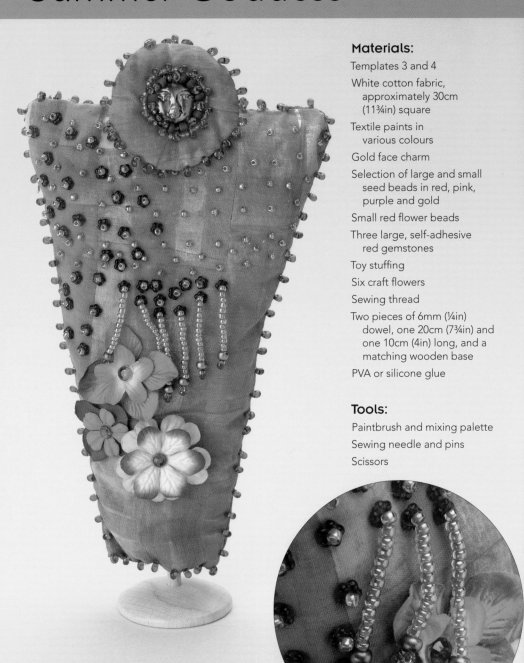

Materials:

Templates 3 and 4

White cotton fabric, approximately 30cm (11¾in) square

Textile paints in various colours

Gold face charm

Selection of large and small seed beads in red, pink, purple and gold

Small red flower beads

Three large, self-adhesive red gemstones

Toy stuffing

Six craft flowers

Sewing thread

Two pieces of 6mm (¼in) dowel, one 20cm (7¾in) and one 10cm (4in) long, and a matching wooden base

PVA or silicone glue

Tools:

Paintbrush and mixing palette

Sewing needle and pins

Scissors

Instructions:

1 Place the shorter length of dowel across the longer length, 1.5cm (¾in) from one end, to form the shoulders. Glue it into position and allow to dry.

2 Paint the fabric in stripes going in both directions to create a multi-coloured surface. Allow to dry.

3 Fold the fabric in half, right sides together, and cut out two body shapes using template 3 and two head shapes using template 4.

4 With right sides together, either hand or machine stitch around the two body shapes, leaving a 5cm (2in) gap at the top and a 1cm (½in) gap in the centre at the bottom. Turn right-side out.

5 Stitch the two head shapes together leaving a small gap. Pad the head with toy stuffing and sew up the gap.

6 Insert the dowel frame through the neck end of the body shape so that the end protrudes through the gap in the bottom. Stitch the bottom of the fabric shape around the dowel.

7 Stuff the body shape from the top until the desired firmness is achieved. Stitch the gap along the shoulders together with hand stitching.

8 Attach the face charm to the head and decorate the head with seed beads. Sew the finished head to the body, in front of the dowel visible at the top of the doll.

9 Decorate the body using seed beads; flower beads with a small seed bead in the centre of each one; craft flowers with gemstone centres; and strings of seed beads.

10 Attach the base to complete the doll.

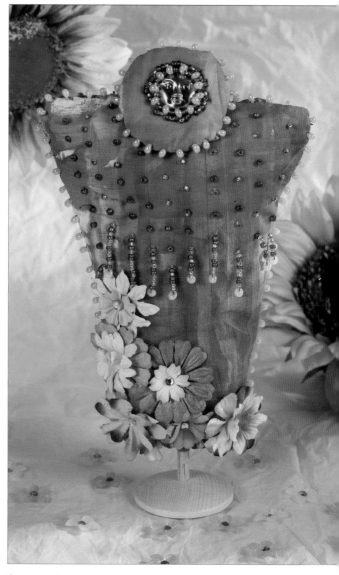

Spring Dawn

This doll can be adorned in various colours and types of beads to create a very different feel. Try creating an autumn or a winter version.

Neptunia

Materials:

Templates 3 and 4

Fabric, approximately 30cm (11¾in) square, with a sea theme

Gold face charm

Various shells with a tiny hole drilled through each one

Selection of large and small seed beads, feature beads and pendant beads in green, blue and white

Large pearlescent ring embellishment

Five gold fish charms

Five gold seahorse charms

Sewing thread

Two pieces of 6mm (¼in) dowel, one 20cm (7¾in) and one 10cm (4in) long, and a matching wooden base

PVA or silicone glue

Tools:

Sewing needle and pins

Scissors

Instructions:

1 Make the body of the doll in the same way as the previous project, though this time there is no need to paint the fabric.

2 Attach the face charm to the head and decorate the head with beads. Sew the finished head to the body.

3 Decorate the body using beads; strings of shells, seed beads and charms; and the large, pearlescent ring held in place with strings of seed beads.

4 Attach the base to complete the doll.

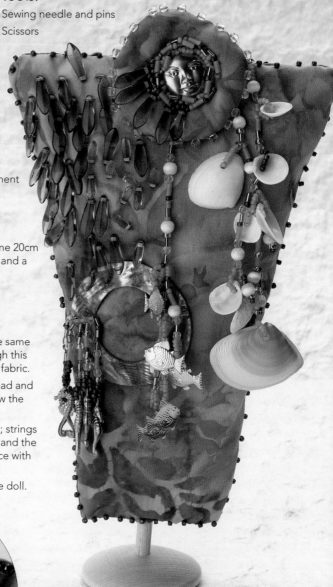

Oceanus

Use different beads and charms, such as these wooden fish, to make a sea-loving doll of your own creation.

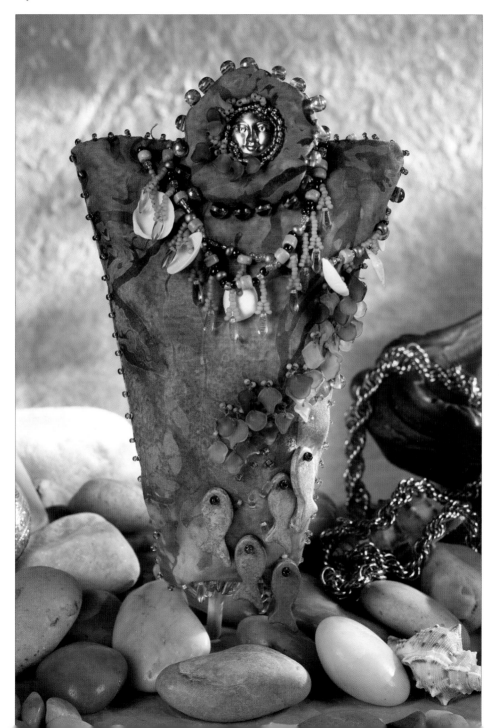

Wired Woman

Materials:

Template 5

Selection of bendable wires in different colours and thicknesses

Various beads (with holes large enough for the wires to pass through)

Tools:

Round-nosed pliers

Wire cutters

Instructions:

1 Make the outline for the doll out of thick wire using template 5. Make a heart shape and a circle to fit inside the head, also using thick wire.

2 Place the heart shape in the centre of the body and the circle within the head, and wrap finer wires around and across the outline, connecting them to the heart shape and the circle. Thread beads on to some of the wires as you work.

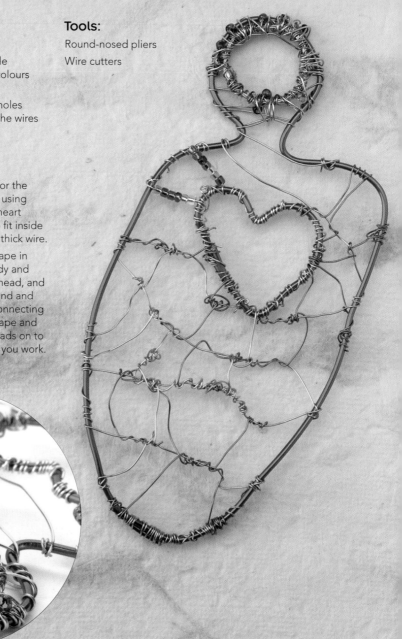

Wired and Wonderful

Let your imagination run wild to create a whole range of wired dolls.

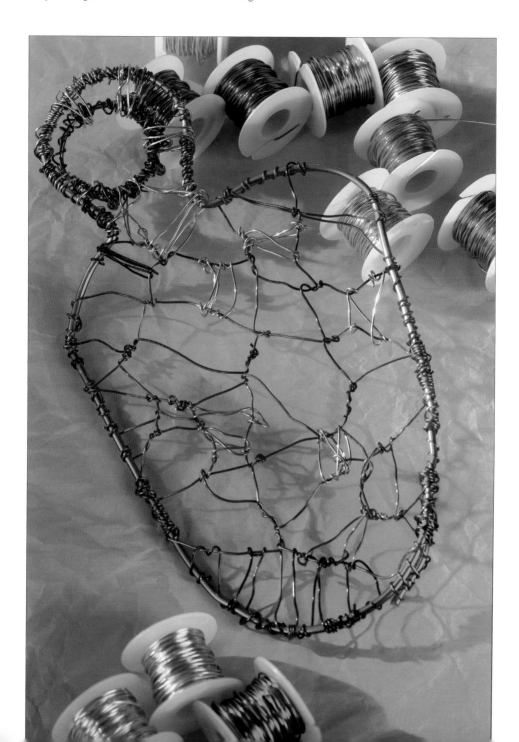

Tin-Can Ally

Materials:

Small, shallow tin can

Large gold face charm

Selection of metal items, e.g.
bottle caps, wing nuts, nails,
sections of metal tube,
washers, mesh, old
keys, etc.

Various wires of
different thicknesses

Copper tape

Metal glue

Tools:

Round-nosed pliers

Wire cutters

Soldering iron and solder

Metal punch

Note: This project
involves using solder
and a soldering iron,
and the necessary
safety precautions, as
recommended by the
manufacturer, should be
taken. Alternatively, pieces
of metal can be joined
together using metal glue.

Instructions:

1 Seal the edges of the empty
tin can with copper tape to
make it safe.

2 Construct the body using
the various metal items you
have collected together.
Create the hands using a
medium-weight wire and wrap
the fingers, palm and back of
each one using fine gold wire
(see page 14).

3 Complete the doll by
adding a large face charm.

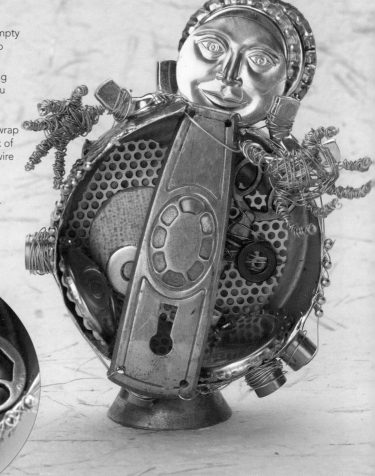

Bits 'n' Bob

This doll is a fantastic way of utilising scrap metal objects, so start
collecting now!

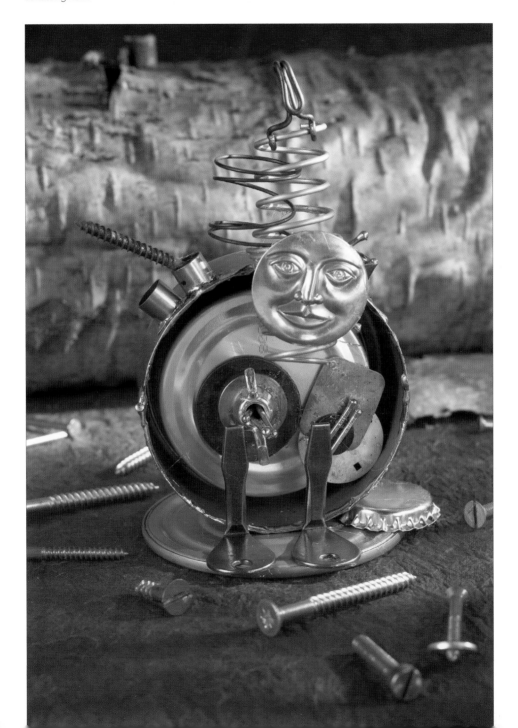

Heart of Glass

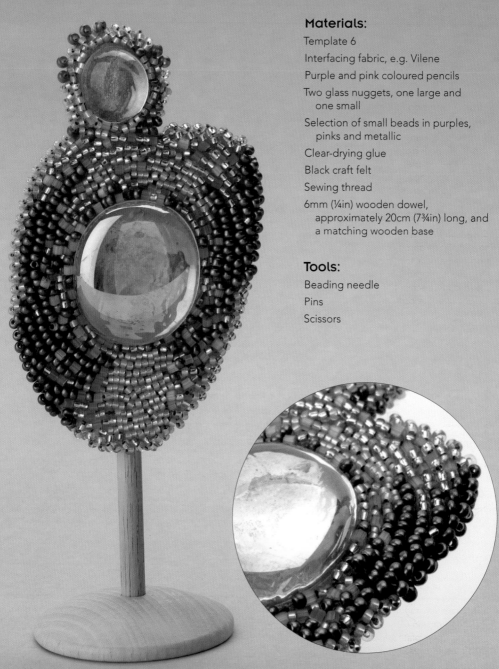

Materials:

Template 6

Interfacing fabric, e.g. Vilene

Purple and pink coloured pencils

Two glass nuggets, one large and
 one small

Selection of small beads in purples,
 pinks and metallic

Clear-drying glue

Black craft felt

Sewing thread

6mm (¼in) wooden dowel,
 approximately 20cm (7¾in) long, and
 a matching wooden base

Tools:

Beading needle

Pins

Scissors

Instructions:

1 Cut out the shape of the body from interfacing using template 6.

2 Use coloured pencils to colour the surface of the interfacing using similar colours to the beads. (If the fabric is left white, it will show behind the beads.)

3 Glue the two flat-backed glass nuggets on to the fabric. Allow to dry.

4 Fill the remaining area of the fabric with beads until the surface is completely filled. Stitch on the beads in groups of three, and arrange them carefully to create patches of different colour and texture.

5 Cut another shape from the felt using the same template and over-sew it to the back of the doll, threading a single bead on to each stitch (the beads give the doll a rope-like edging).

Golden Girl

To make a richer-looking, more elaborate version of this doll, use the larger template (template 5) and pack the beads more tightly.

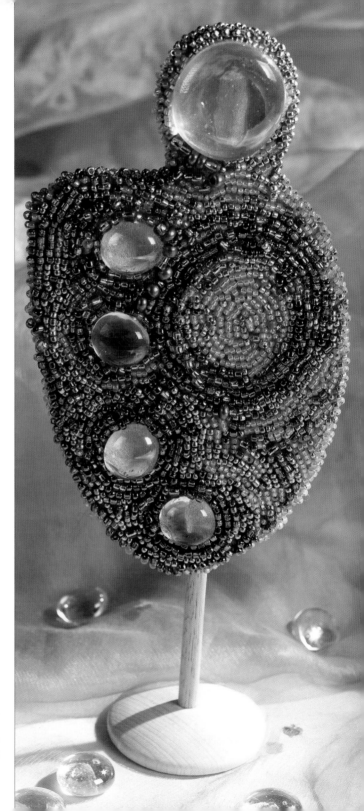

Man of Dreams

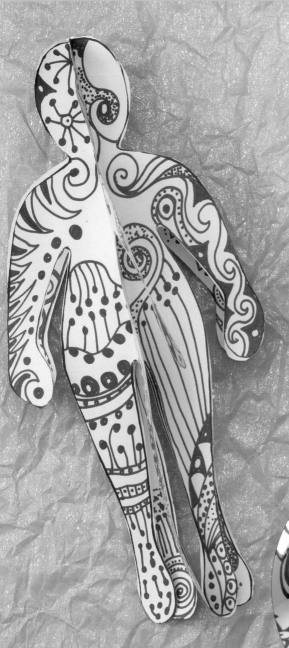

Materials:

Template 1
Lightweight card
Paper glue
Black felt-tip pen

Tools:

Scissors

Instructions:

1 Make five copies of template 1 on lightweight card and cut them out.

2 Fold each copy of the doll's outline in half as accurately as possible.

3 Glue the backs of the folded shapes together to form a three-dimensional figure. Trim and neaten any edges that don't quite meet. Allow to dry thoroughly.

4 Decorate the doll in whatever way you choose using the felt-tip pen.

Woman of Soul

More complicated designs can be applied before the doll is assembled – the choice is yours. Try constructing the doll out of more cut-out shapes for a sturdier version.

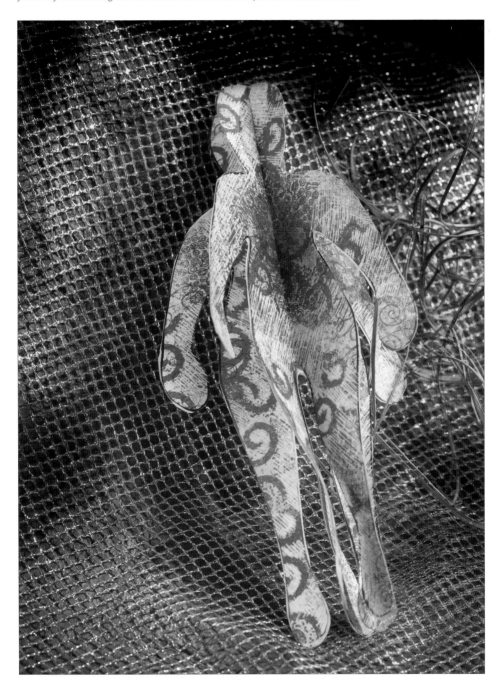

Button Up!

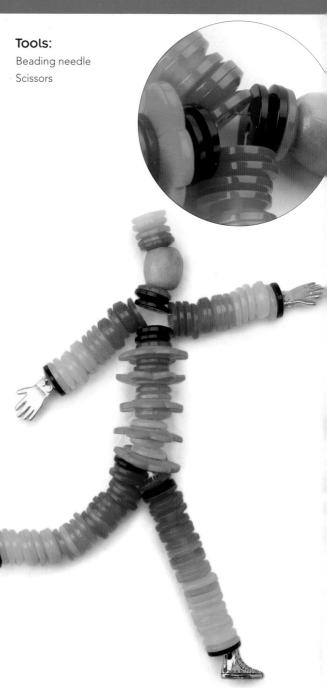

Materials:

Similar-sized two-hole buttons in a range of colours

Five large, two-hole flower buttons

Large wooden bead for the head

Two shoe and two hand charms, e.g. 'Sneaker Shoe' and 'Glove Hand' by Artgirlz

Strong sewing thread

Tools:

Beading needle

· Scissors

Instructions:

1 Thread the needle with a long length of thread. Pass the thread down through a stack of five buttons and back up again, then pass both threads through the large bead to form the head.

2 Take one thread through one hole of three buttons and the other thread through the other hole to make the neck.

3 Select buttons for the arms and take the left-hand thread through one hole of one stack of buttons for the left arm, and the other thread through one hole of the second stack of buttons for the right arm.

4 At the end of each arm add a hand charm and pass the thread up the arm though the second hole in each button.

5 Make a stack of buttons for the body, including the flower buttons, in the same way as you made the neck (step 2).

6 Continue down into the legs using the same technique as for the arms, this time attaching a shoe charm at the end of each one. Knot the two threads together to complete.

Flowerpot Man

Any old buttons can be used to make this doll – here I have mixed whites, pinks and purples for a more subdued version.

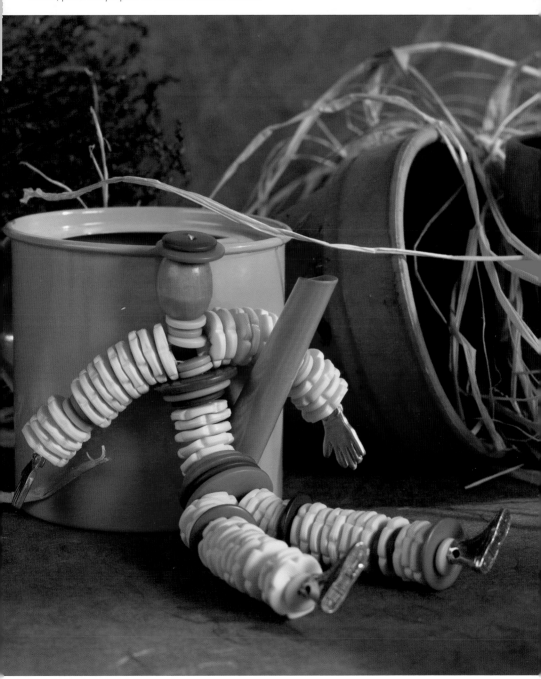

Heartfelt Family

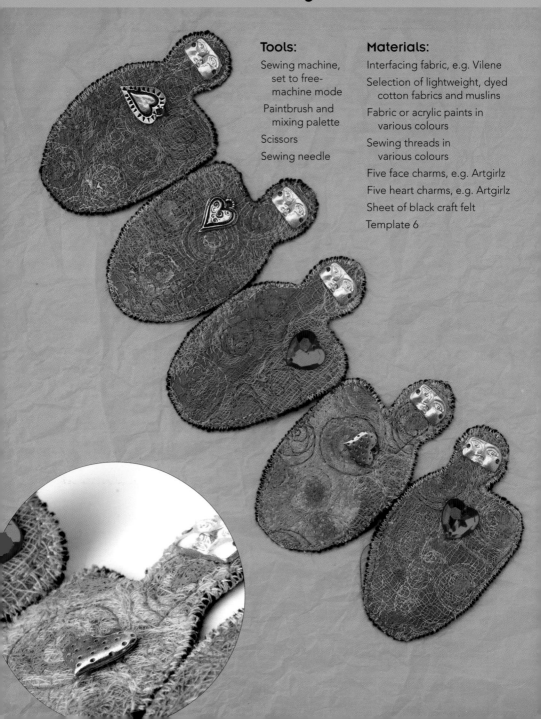

Tools:

Sewing machine, set to free-machine mode

Paintbrush and mixing palette

Scissors

Sewing needle

Materials:

Interfacing fabric, e.g. Vilene

Selection of lightweight, dyed cotton fabrics and muslins

Fabric or acrylic paints in various colours

Sewing threads in various colours

Five face charms, e.g. Artgirlz

Five heart charms, e.g. Artgirlz

Sheet of black craft felt

Template 6

Instructions:

1 Stitch the lightweight cotton and muslins to the interfacing fabric using random free-machining in a range of different colours.

2 Using bold brush strokes, paint patterns on the fabric. Allow to dry. You may choose to repeat the stitch and paint process to achieve a more enriched surface.

3 Using template 6, cut out five shapes using both sides of the template.

4 Place the shapes on to a sheet of black craft felt and stitch around each shape to secure them.

5 Cut out each shape, leaving a small margin of black felt. Zig-zag stitch around the edge of each one, creating a narrow black border.

6 Attach a face charm and a heart charm to each shape. When complete, place the shapes in a row so that the bases are aligned and stitch the points of contact together to form a stitched hinge.

Secret Messengers
Adorn your dolls with sentiment charms as an alternative to this project.

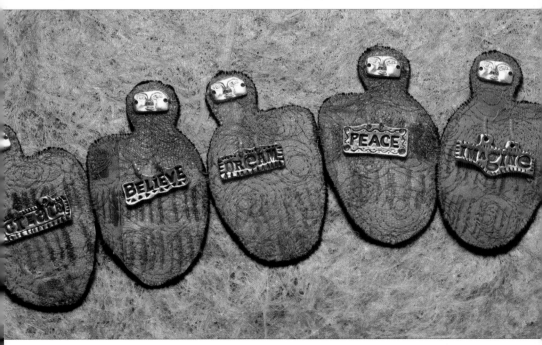

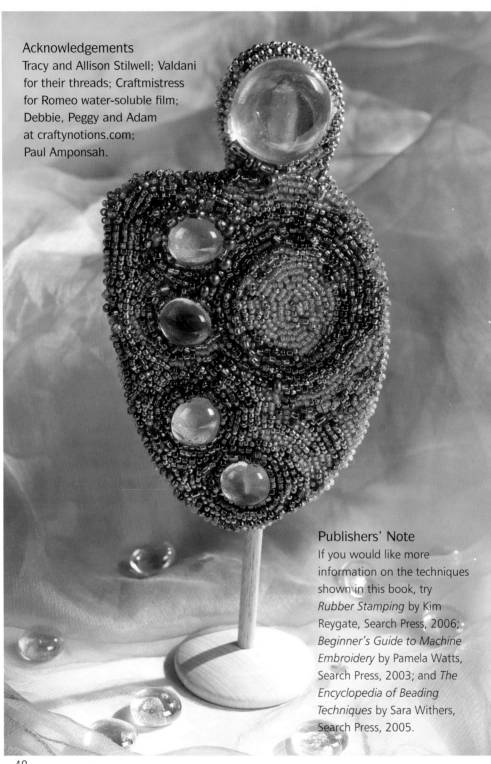

Acknowledgements

Tracy and Allison Stilwell; Valdani
for their threads; Craftmistress
for Romeo water-soluble film;
Debbie, Peggy and Adam
at craftynotions.com;
Paul Amponsah.

Publishers' Note

If you would like more
information on the techniques
shown in this book, try
Rubber Stamping by Kim
Reygate, Search Press, 2006;
*Beginner's Guide to Machine
Embroidery* by Pamela Watts,
Search Press, 2003; and *The
Encyclopedia of Beading
Techniques* by Sara Withers,
Search Press, 2005.